Wisdom With Understanding is Better Than Rubies

Lurine Karon Greenberg
Fine Arts Collection

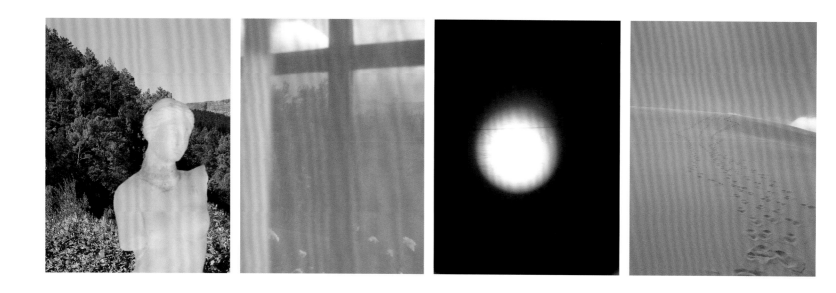

After the Threshold

Sandi Haber Fifield

ESSAY BY VICKI GOLDBERG

KEHRER

[1] Past Portraits, 2011

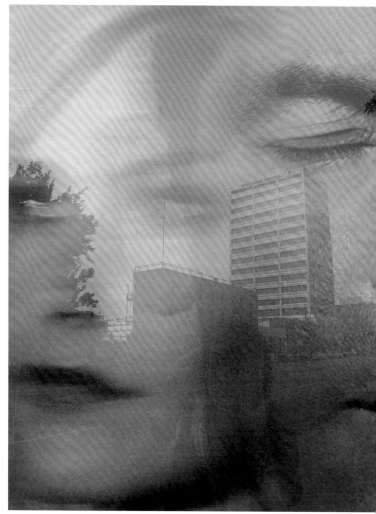

[2] Luck, 2012

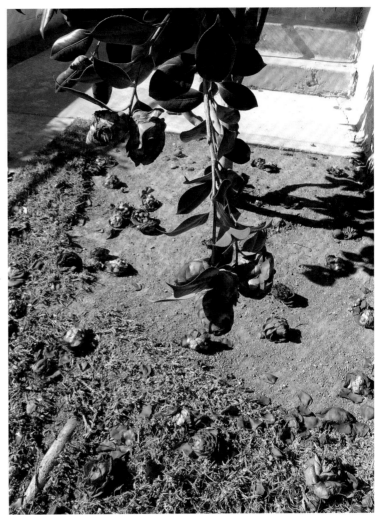

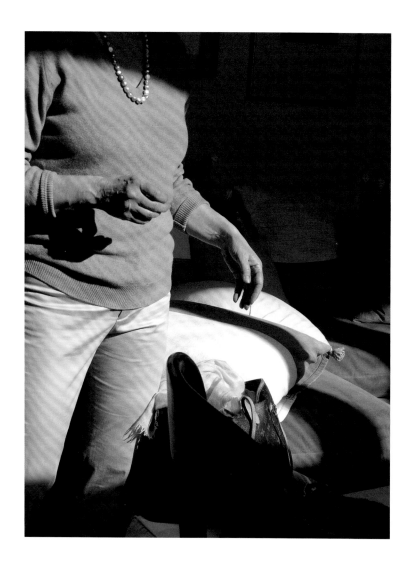

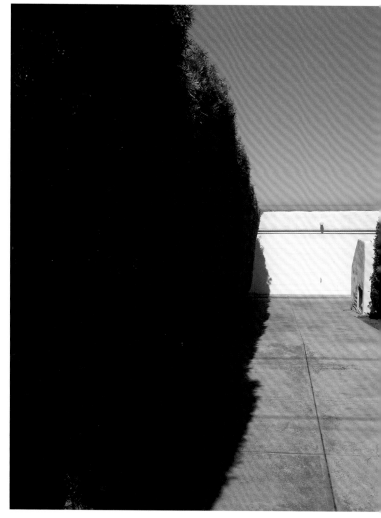

[3] Daylight Moon, 2012

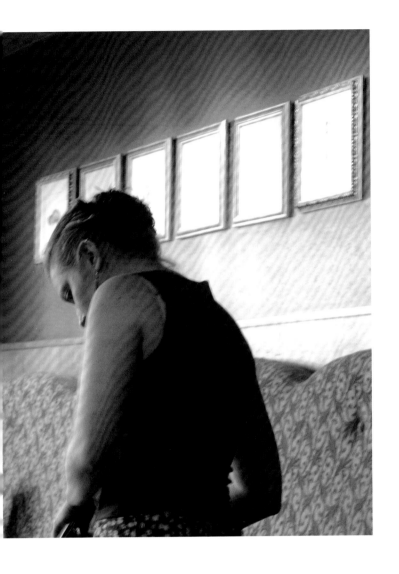
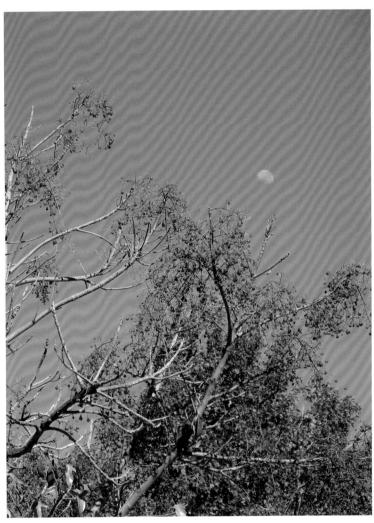

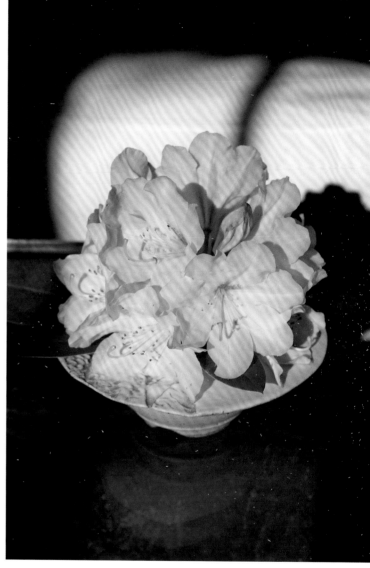

[4] Sunday Morning, 2012

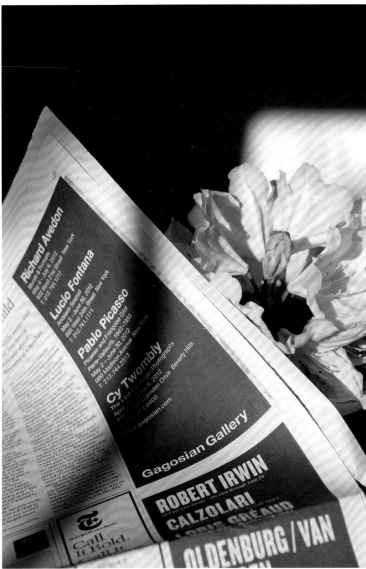

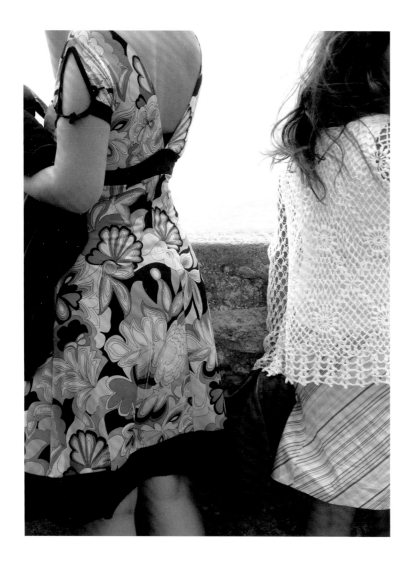

[5] Blue Sky and Jackets, 2011

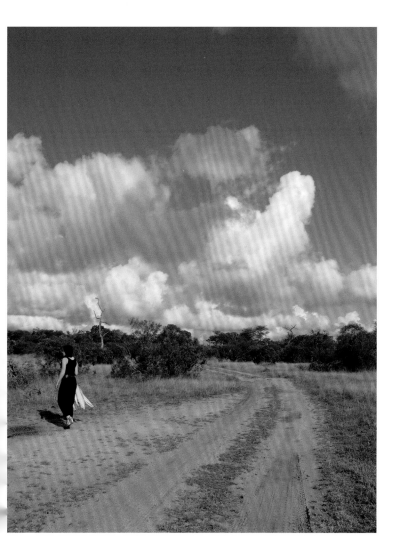

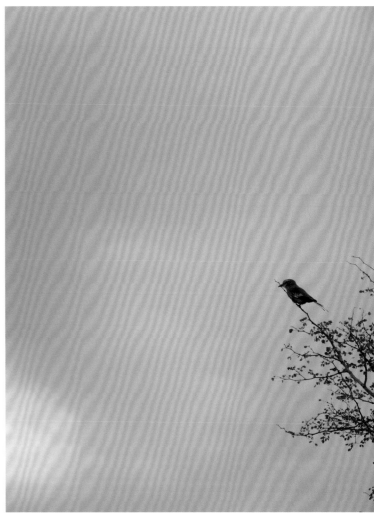

[6] White Sun, 2011

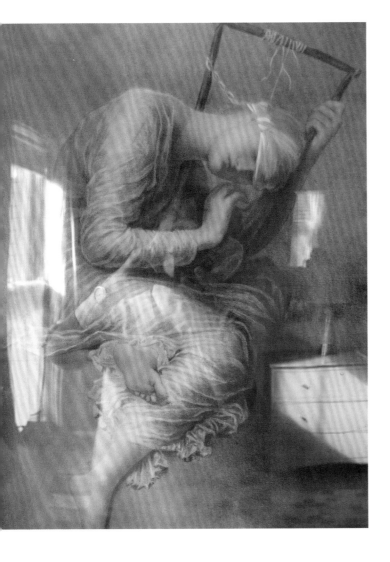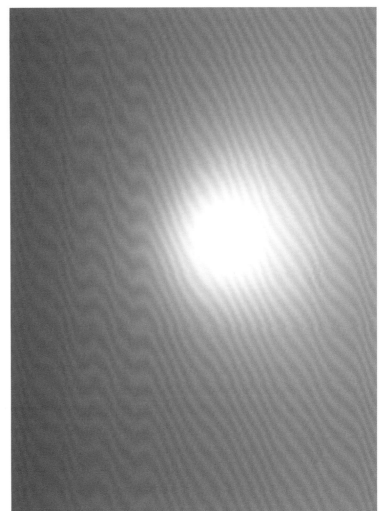

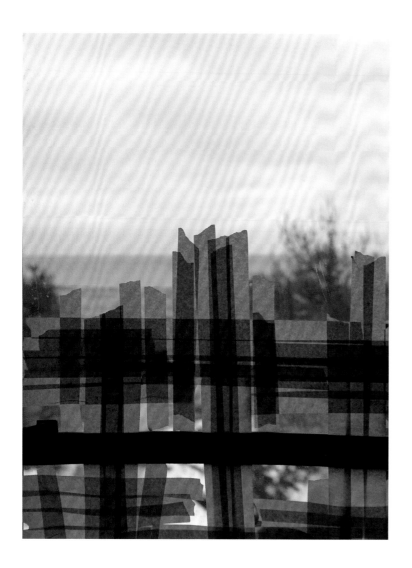

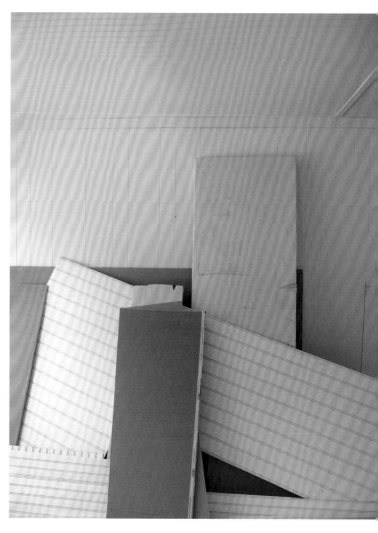

[7] Montauk Blue, 2011

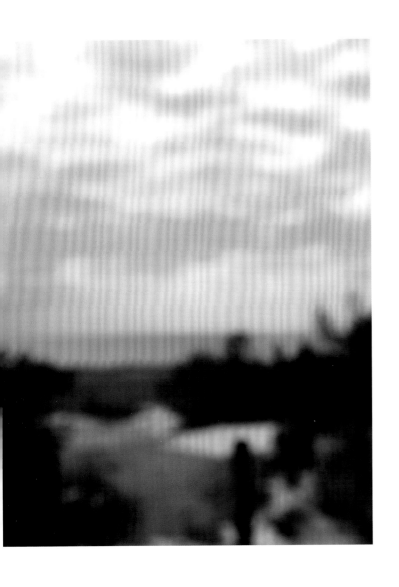

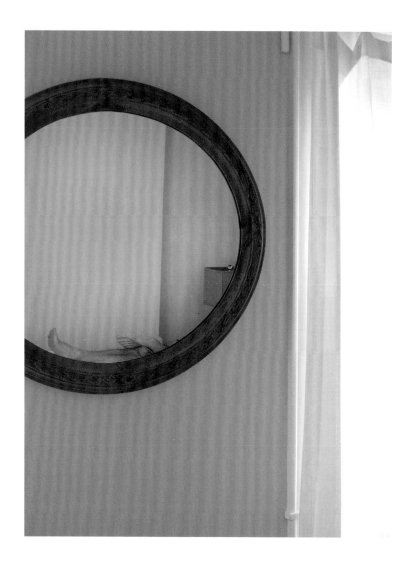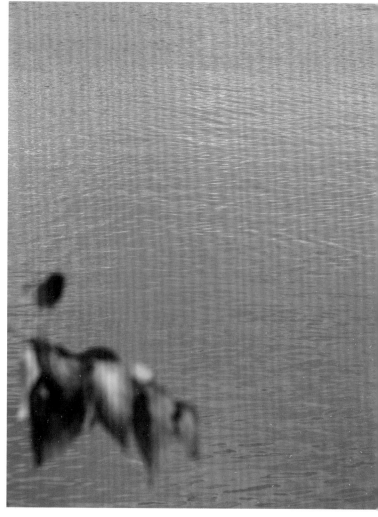

[8] Island Reflections, 2011

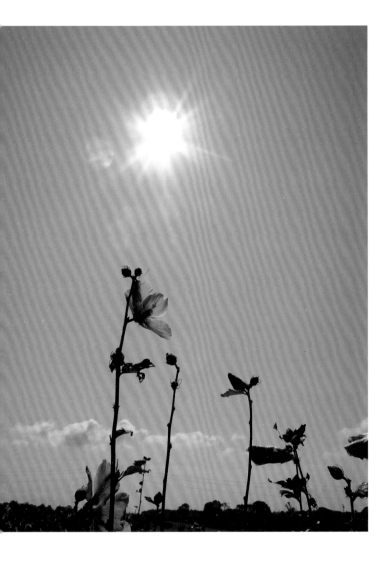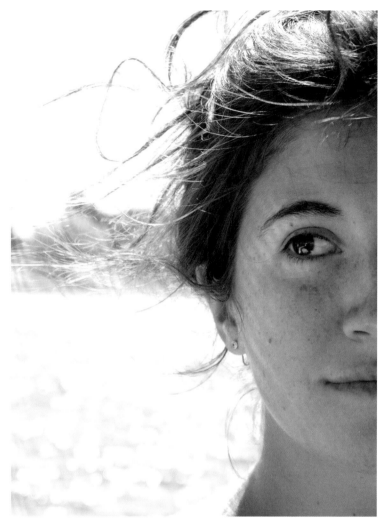

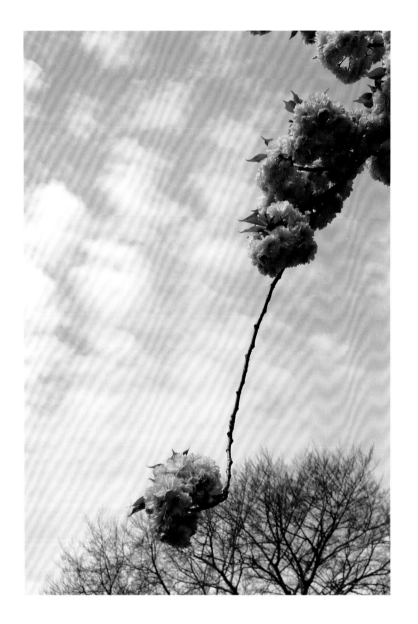

[9] Bent, 2012

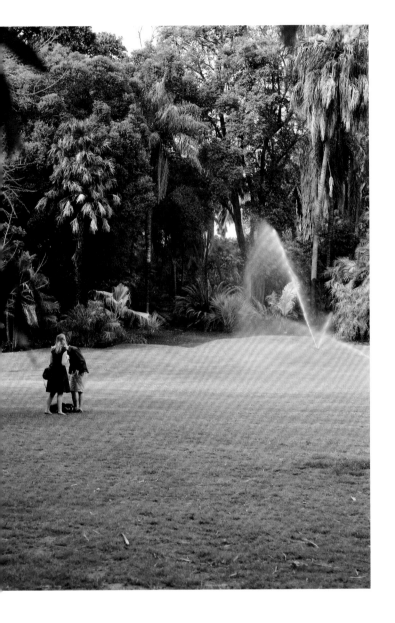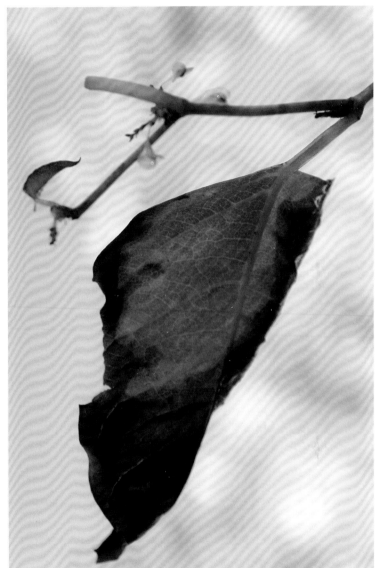

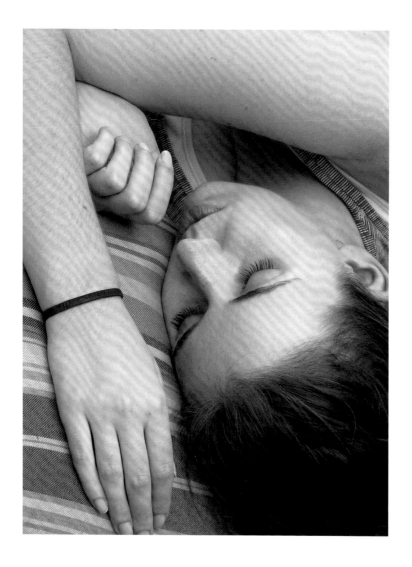

[10] Dreaming in Blue, 2012

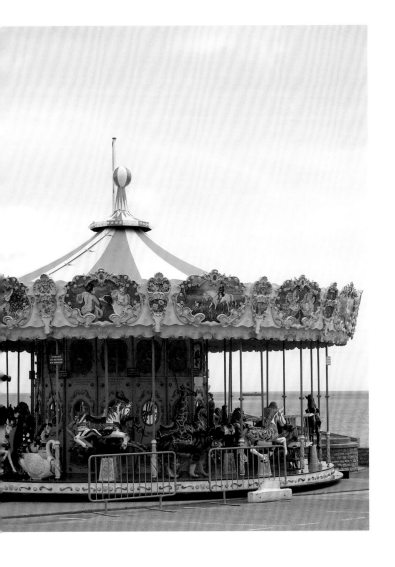
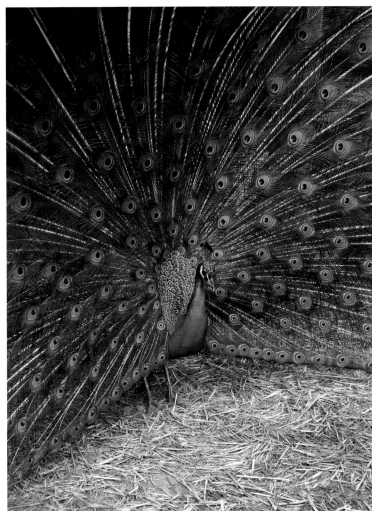

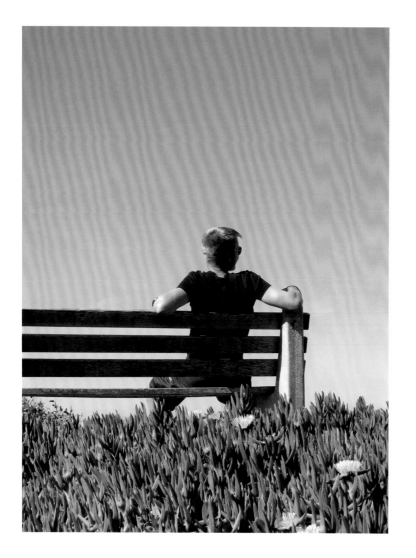

[11] Hidden Man, 2012

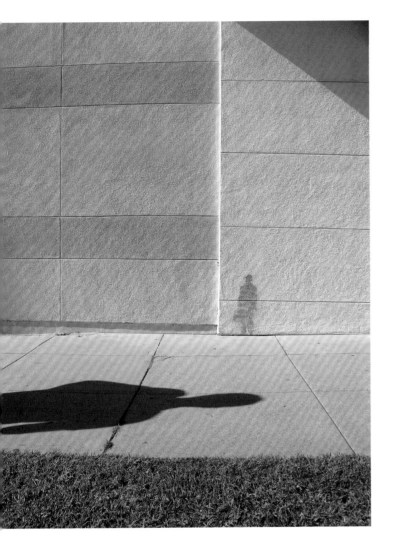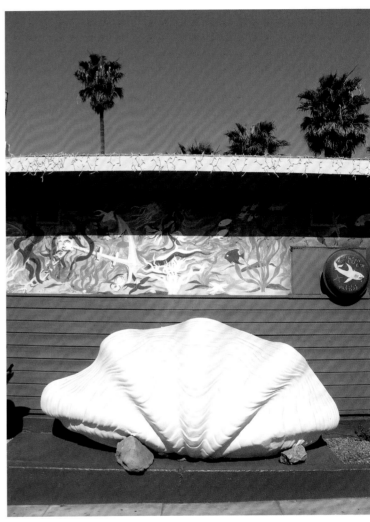

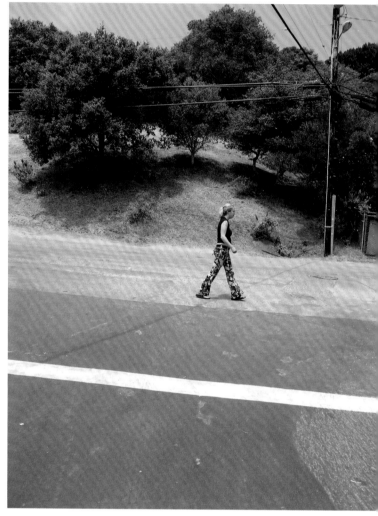

[12] Haywire, 2011

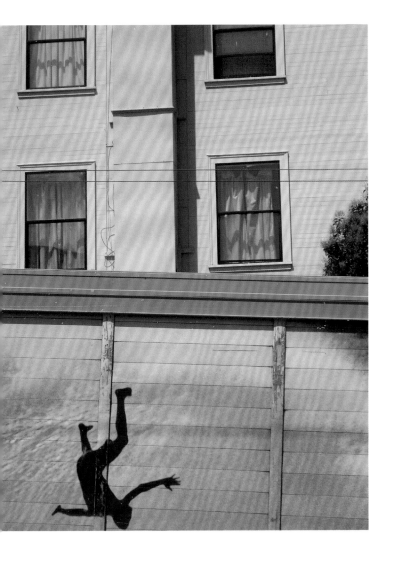
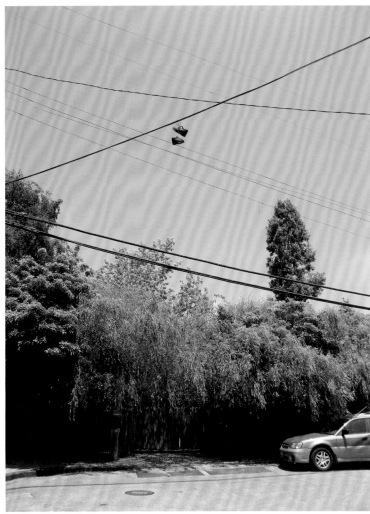

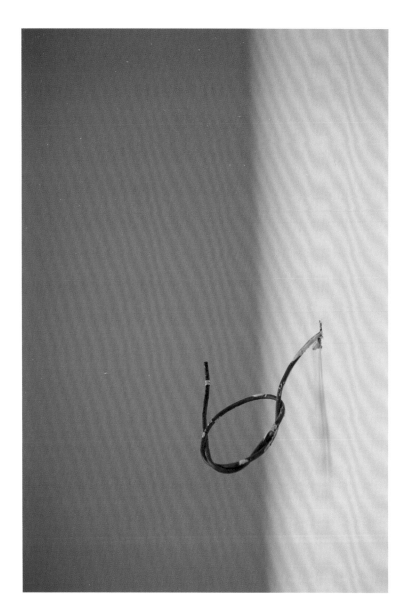
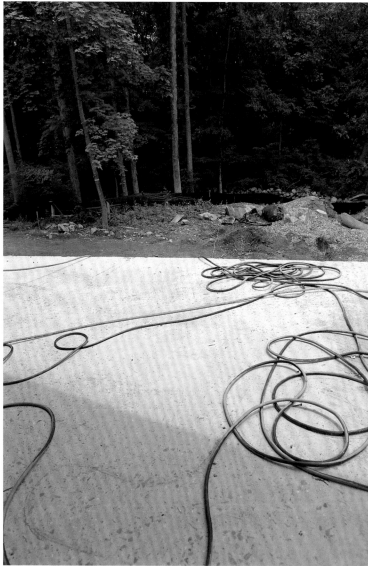

[13] Roughed In, 2011

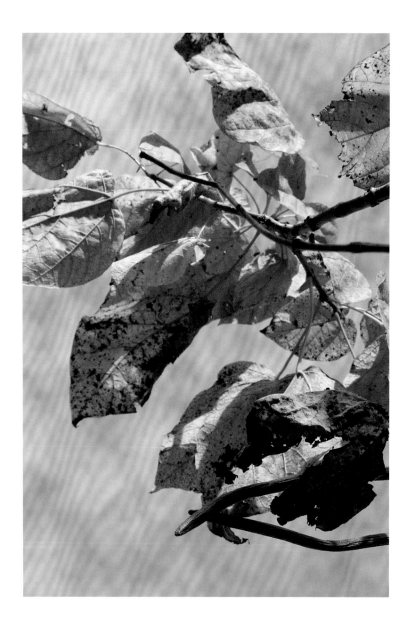
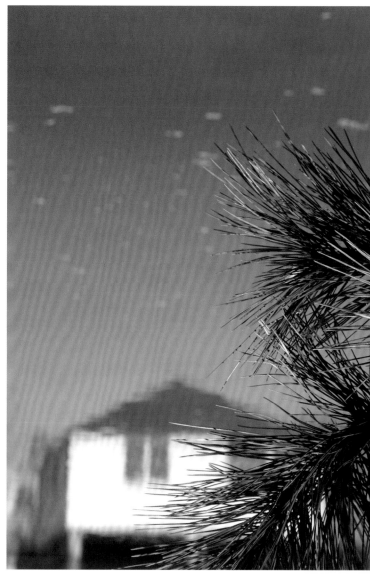

[14] Knotted Vine, 2011

[15] Wandering Monarch, 2010

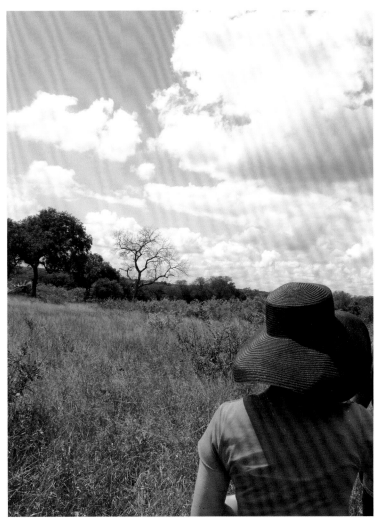

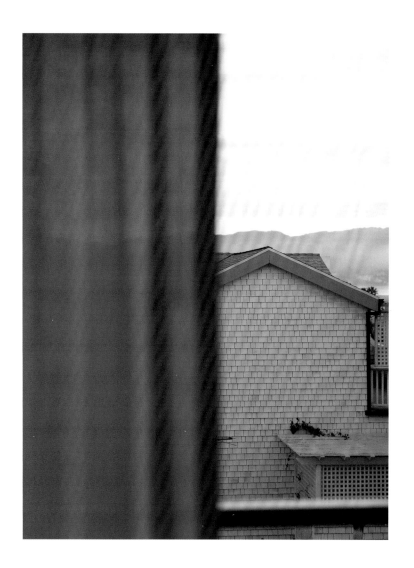
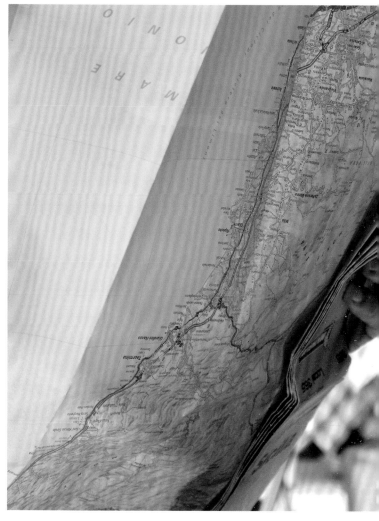

[16] Mare Ionio, 2012

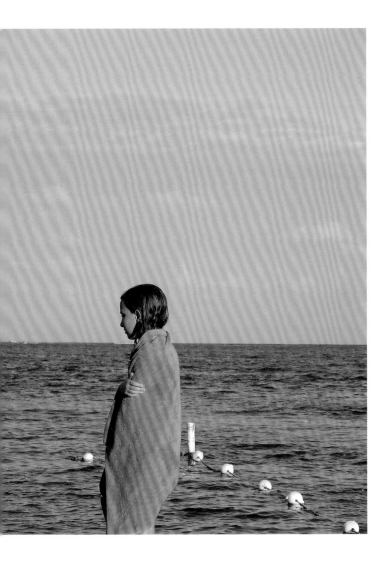
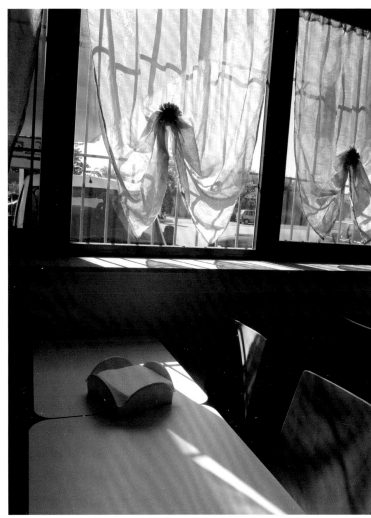

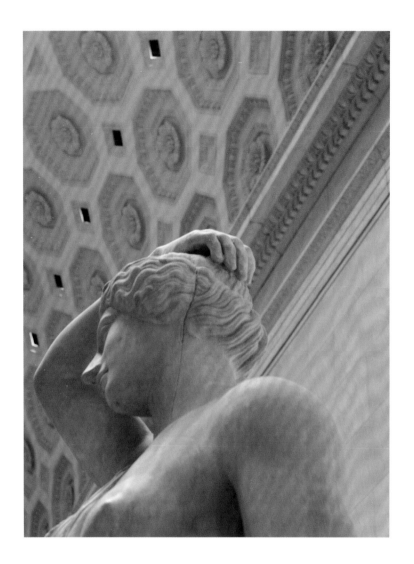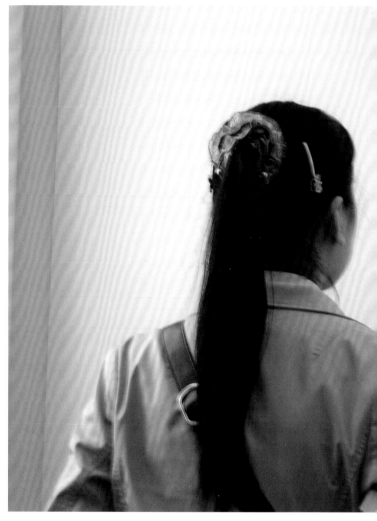

[17] Coffered Perspective, 2012

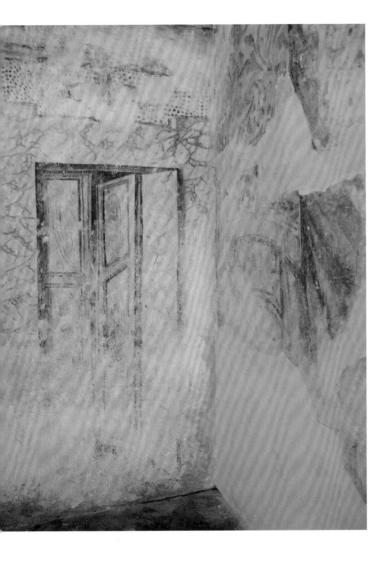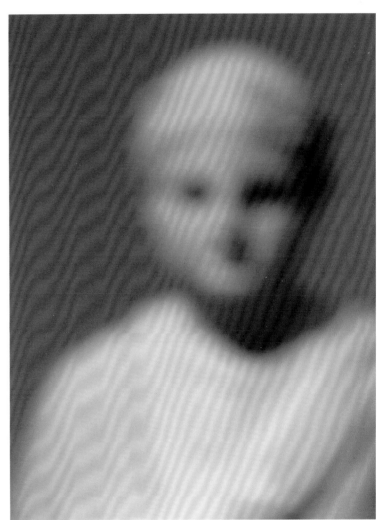

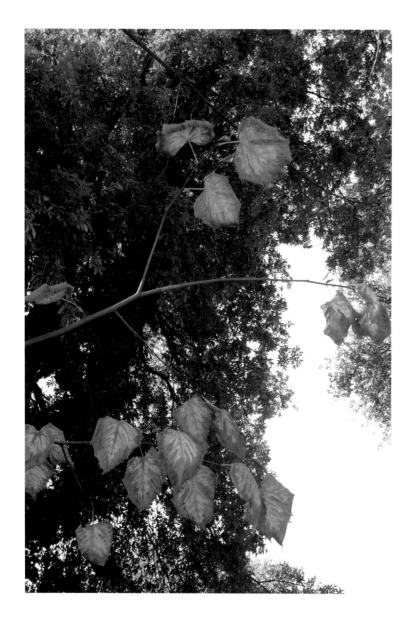

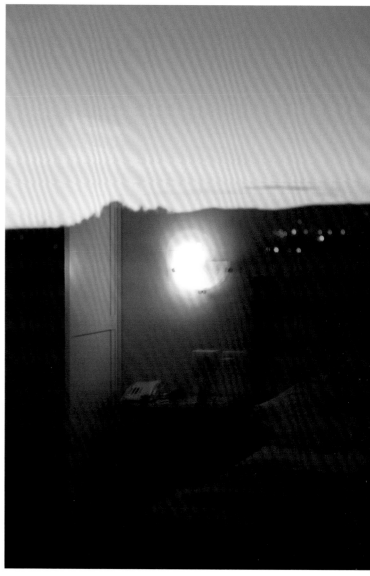

[18] Noto, 2012

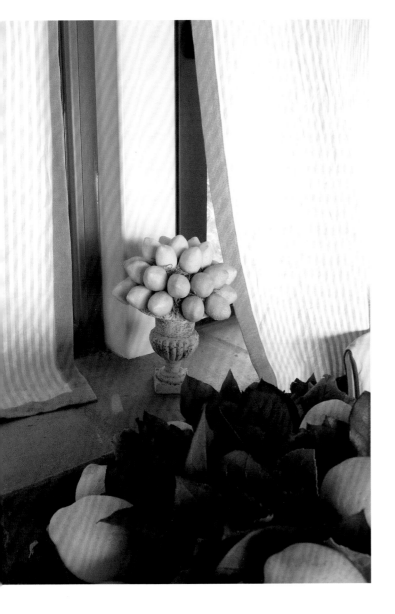
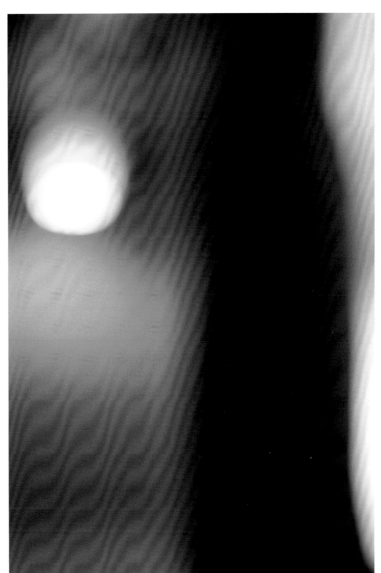

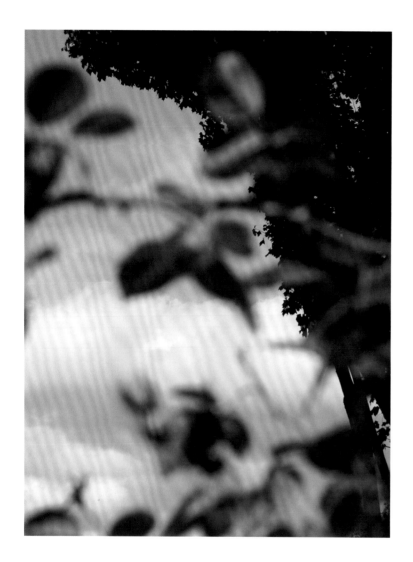

[19] Milkweed Sunset, 2010

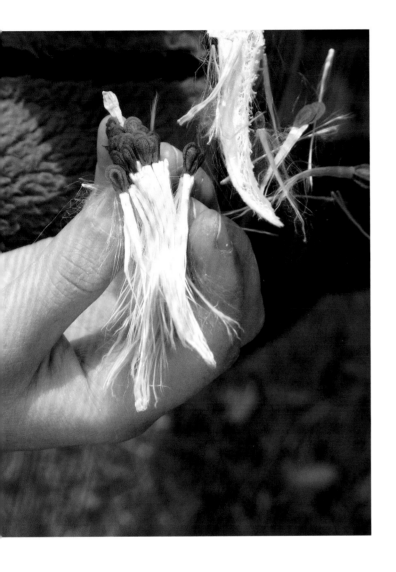
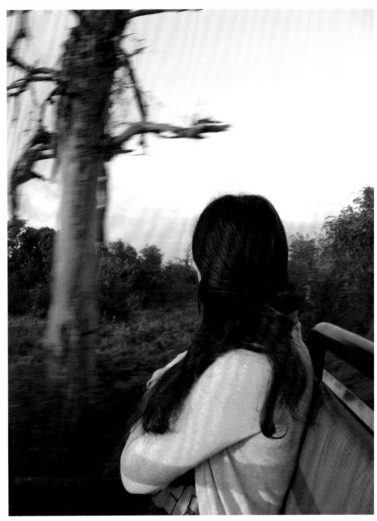

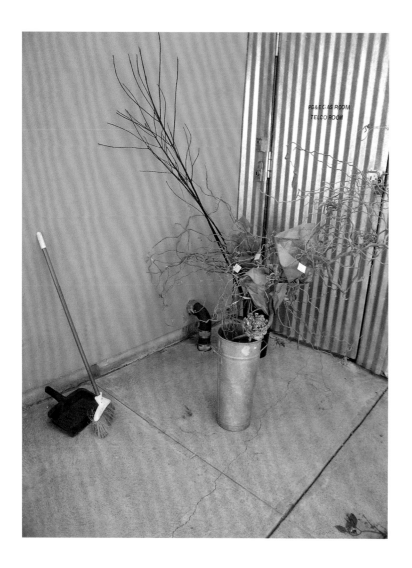

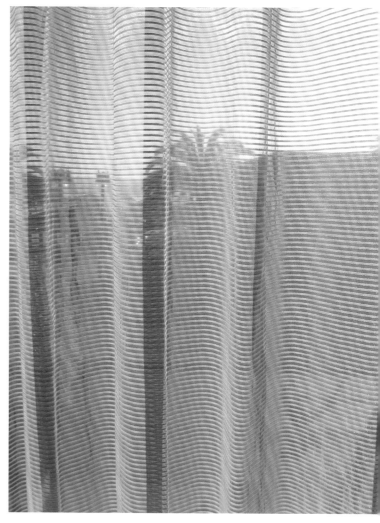

[20] Pleated Light, 2010

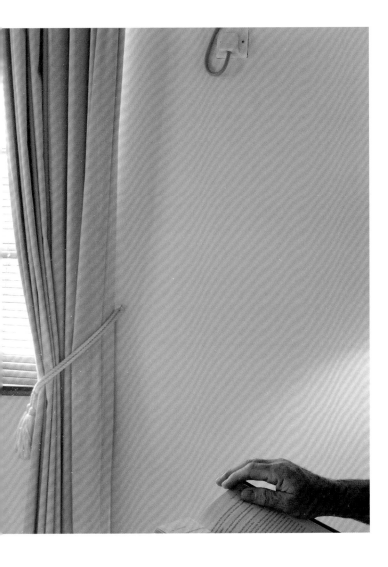

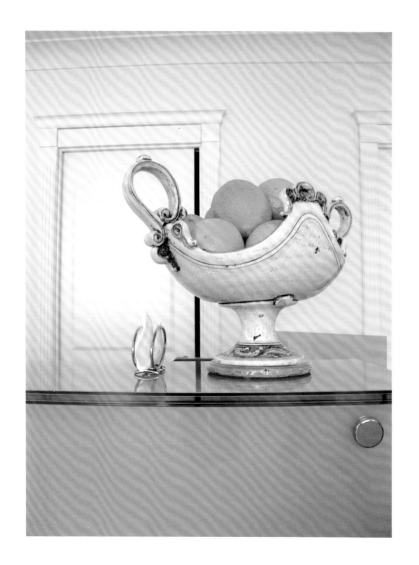

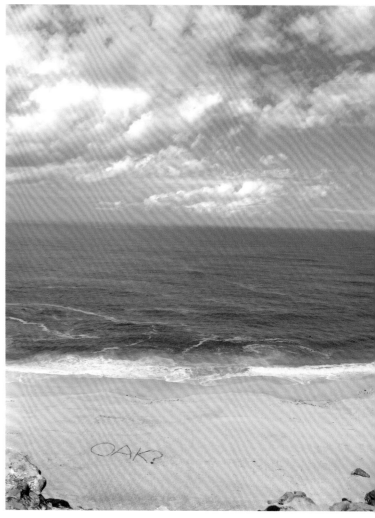

[21] Oak?, 2010

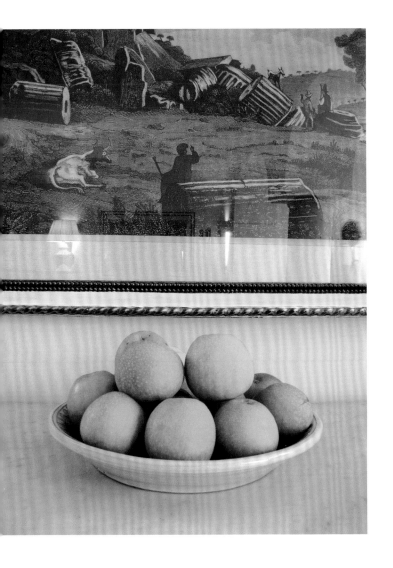
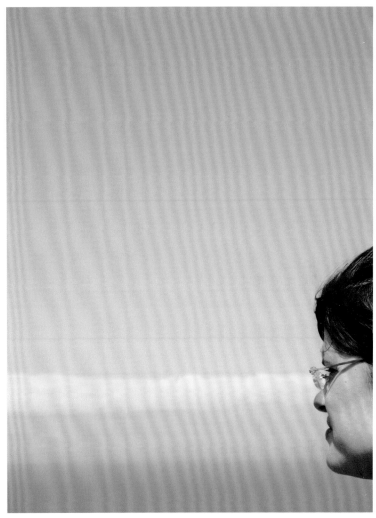

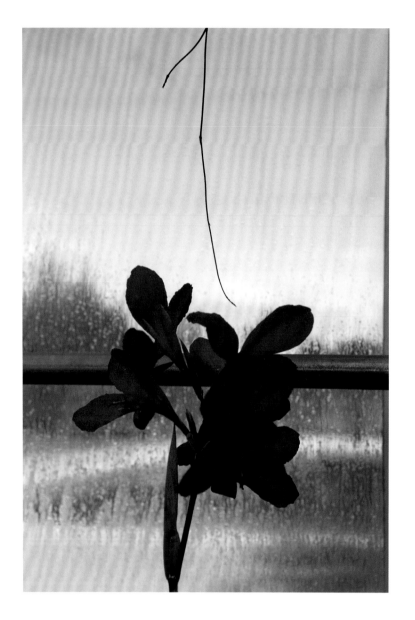

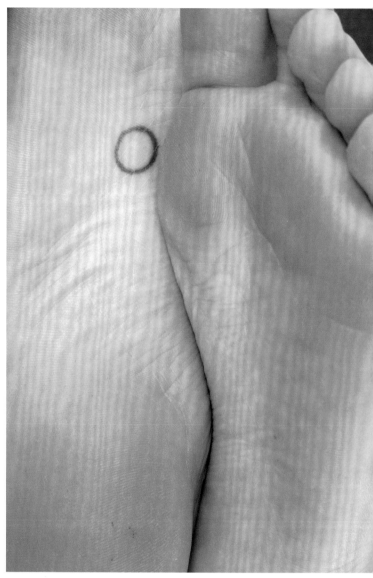

[22] Tattoo, 2011

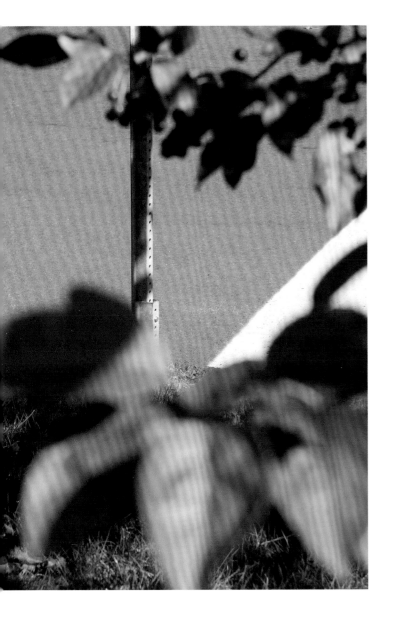
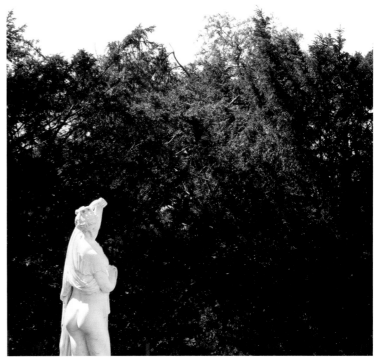

[23] Red Dot, 2011

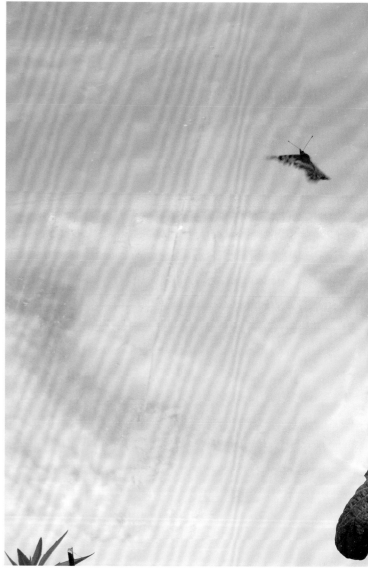

[24] Pained Smile, 2012

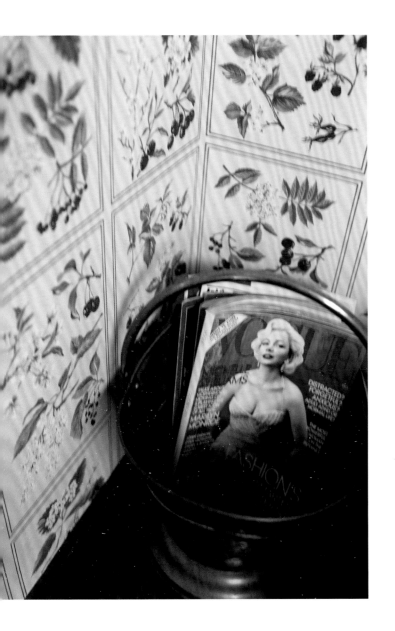

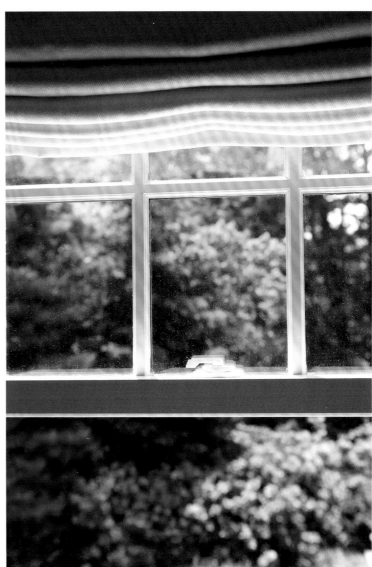

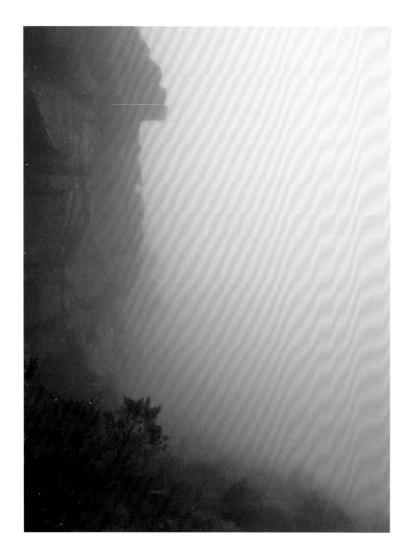

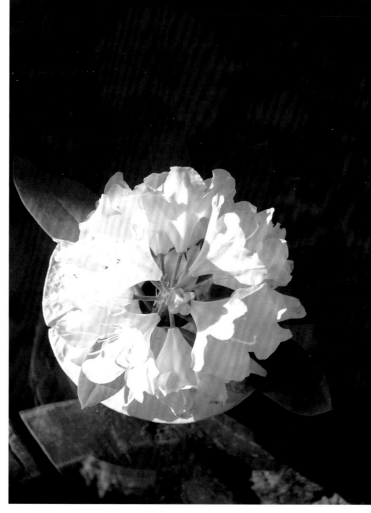

[25] Mademoiselle, 2012

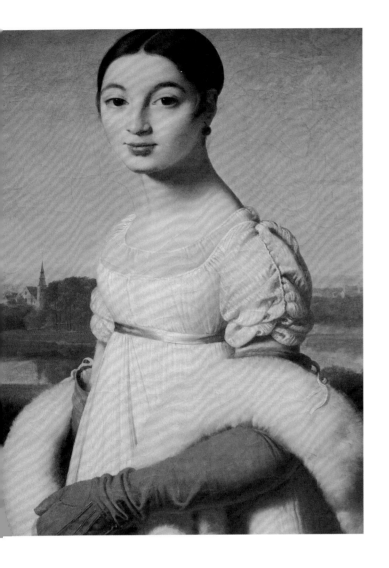

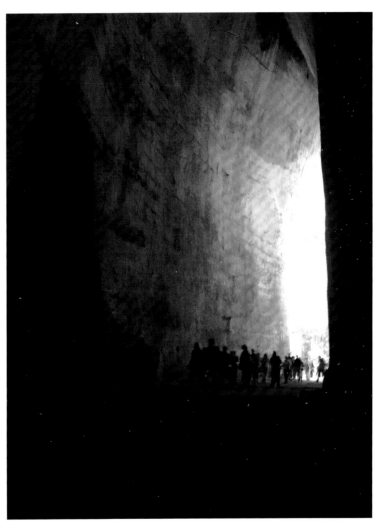

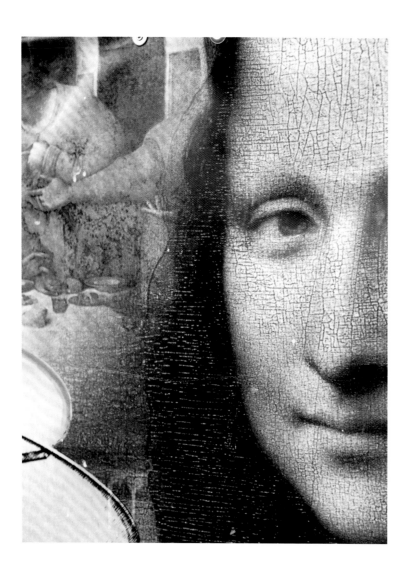
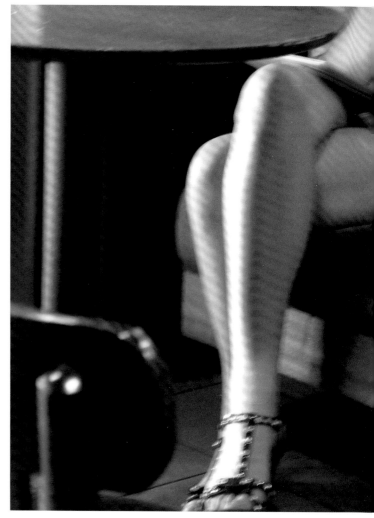

[26] Cornucopia, 2012

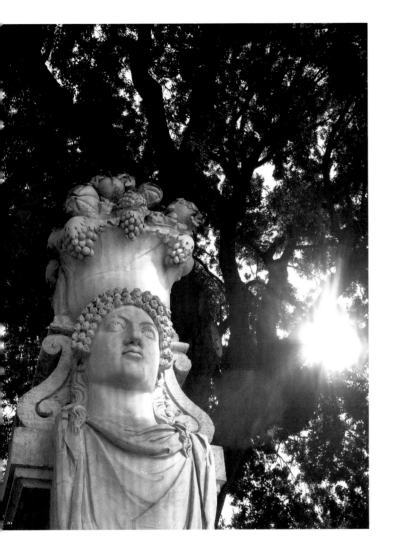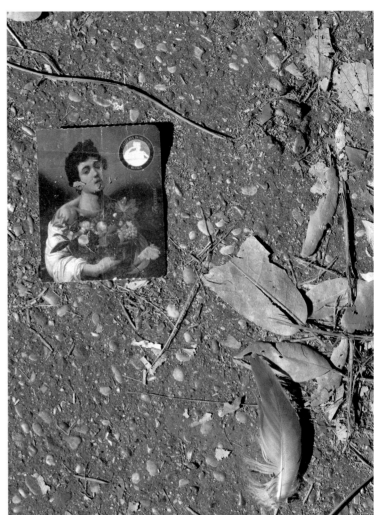

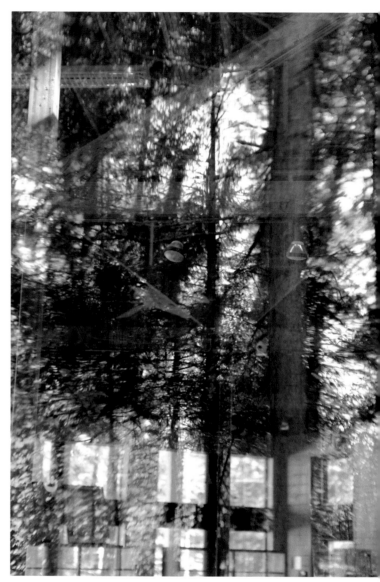

[27] Tanglewood Trio, 2012

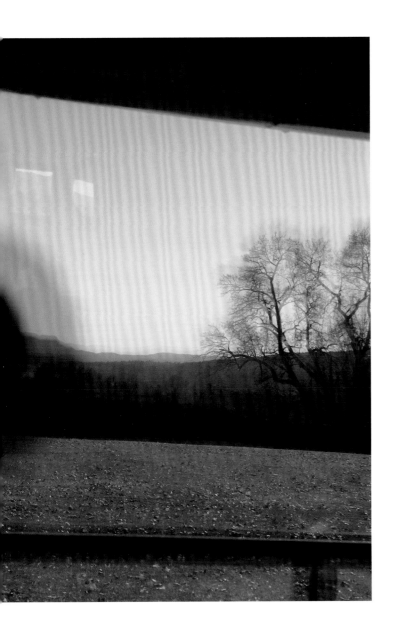

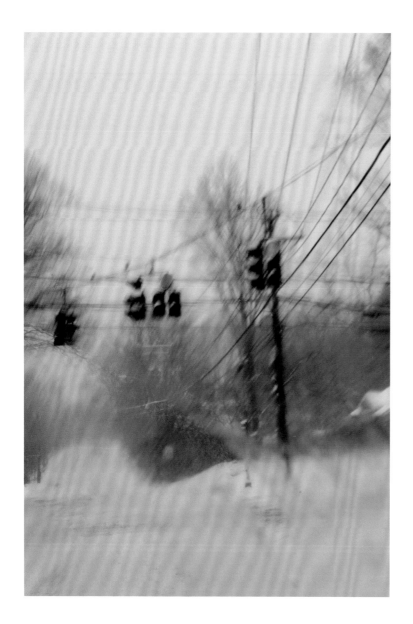
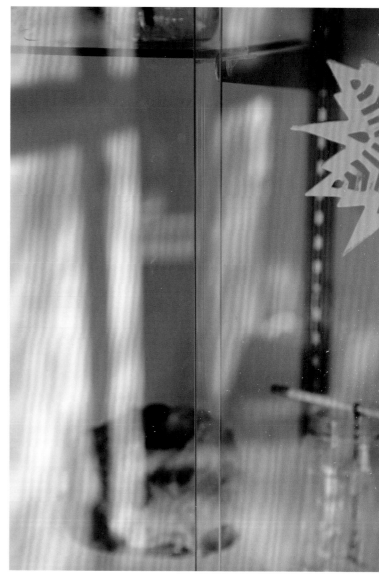

[28] Rock Candy, 2012

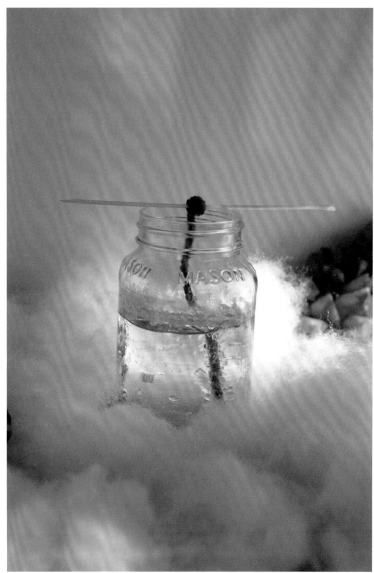

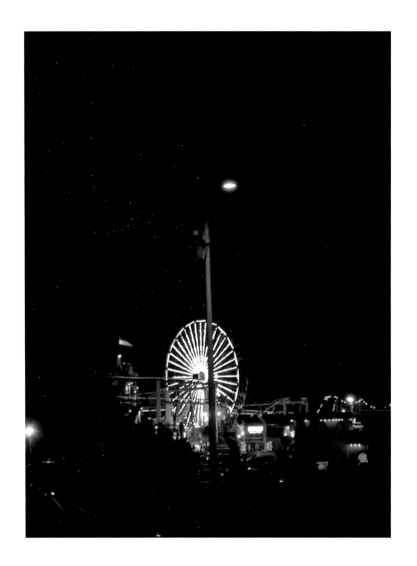
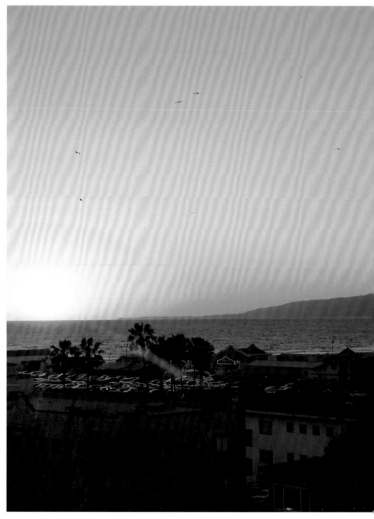

[29] Improbable Night, 2012

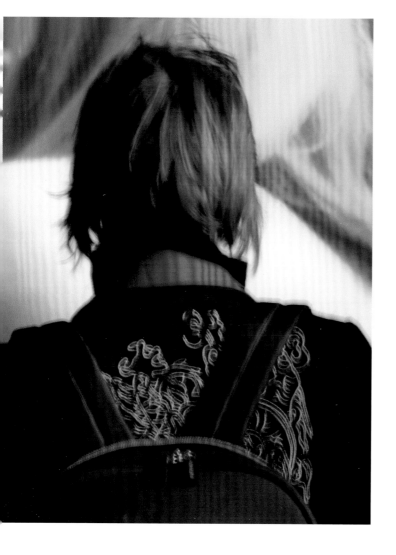
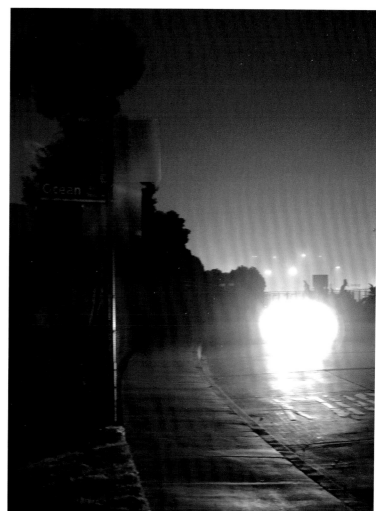

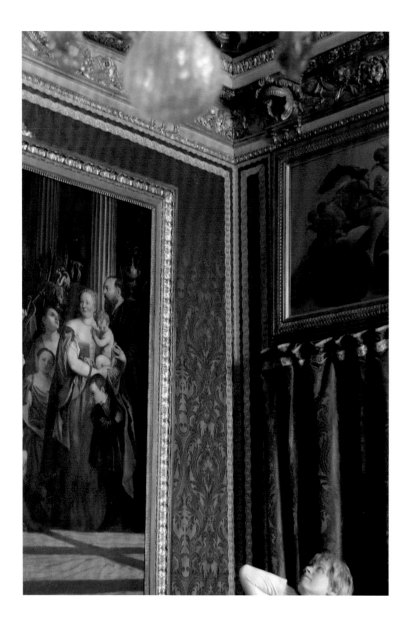
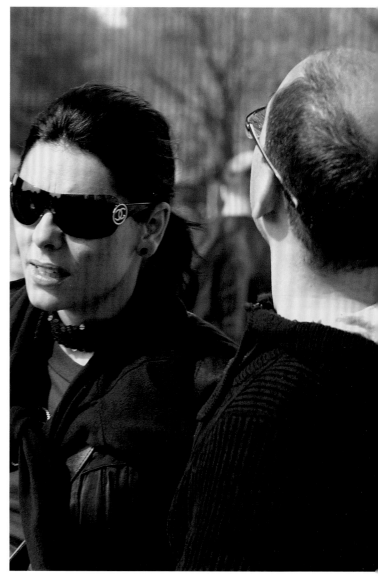

[30] Crystal Gaze, 2008

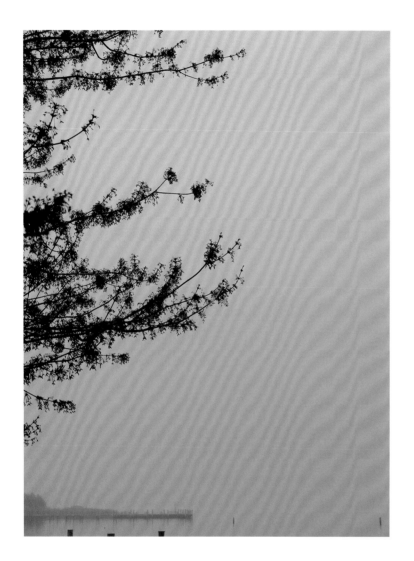

[31] Serene Hour, 2012

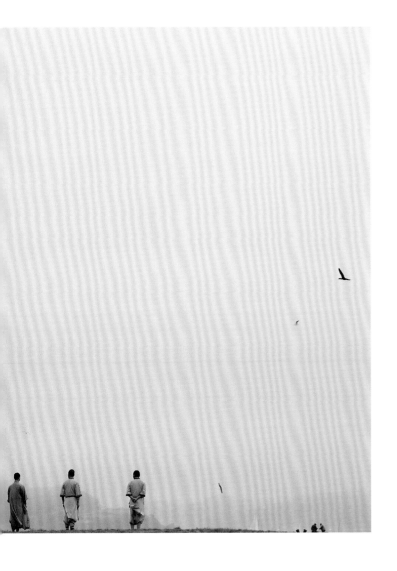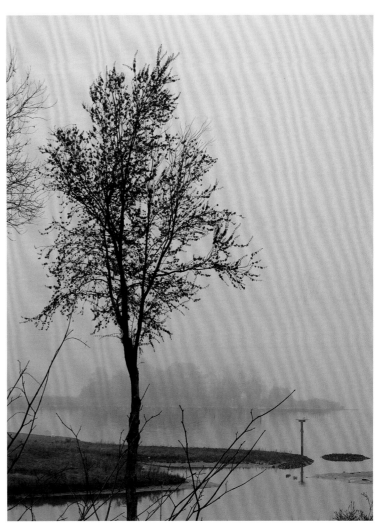

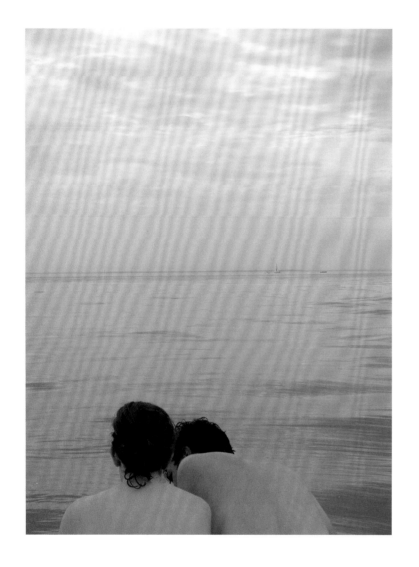
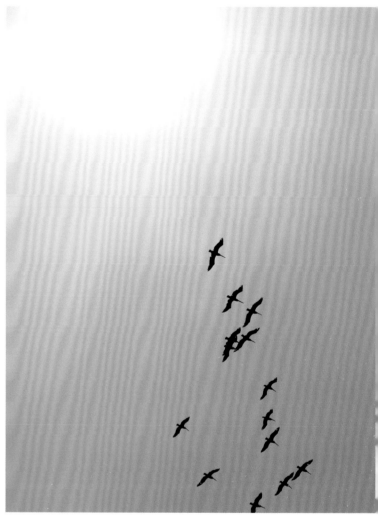

[32] Good Hope, 2010

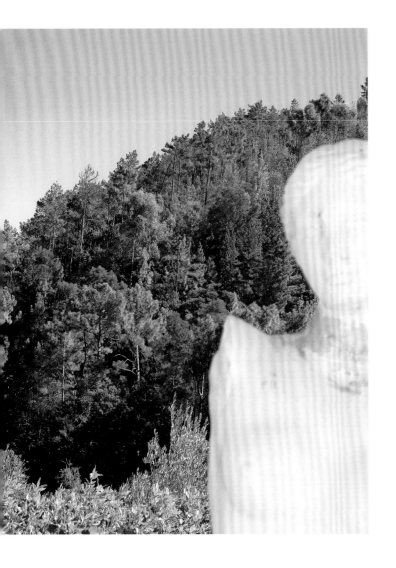
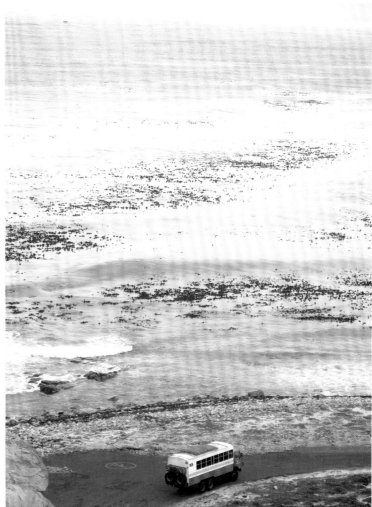

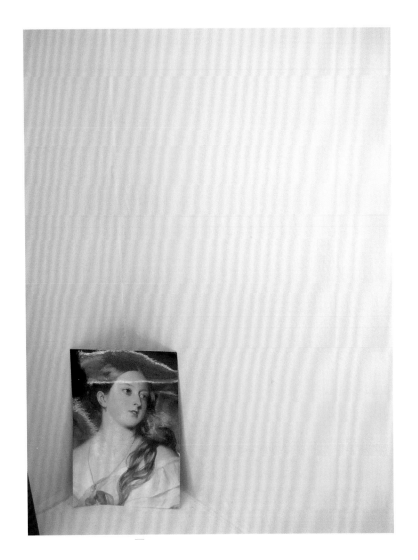

[33] The Young Victoria, 2012

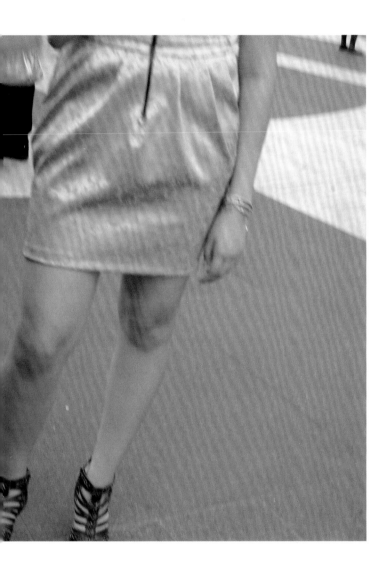

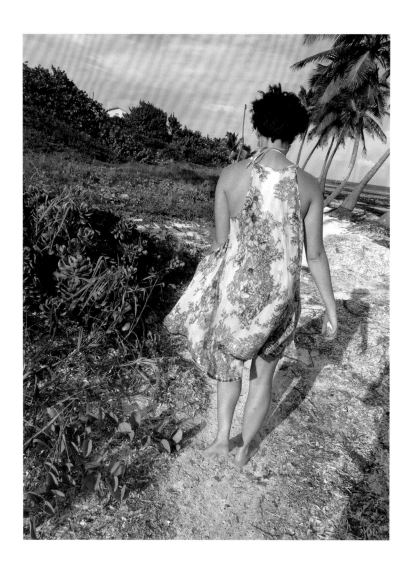

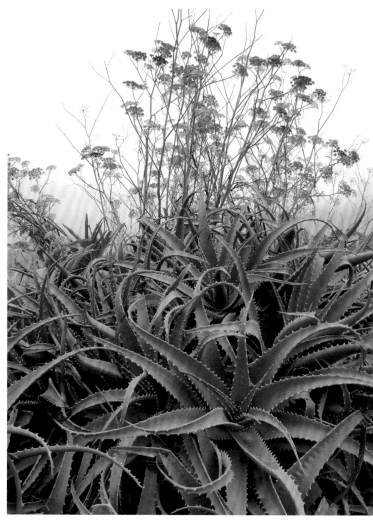

[34] Belize Dress, 2012

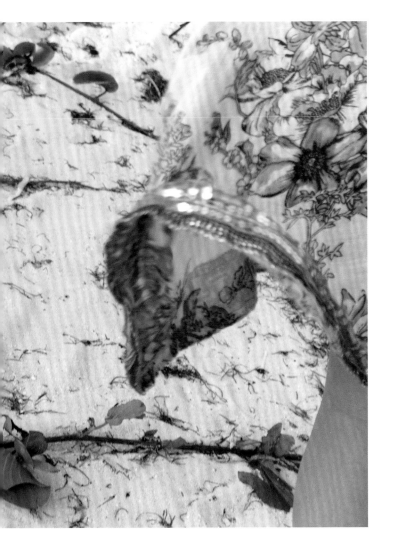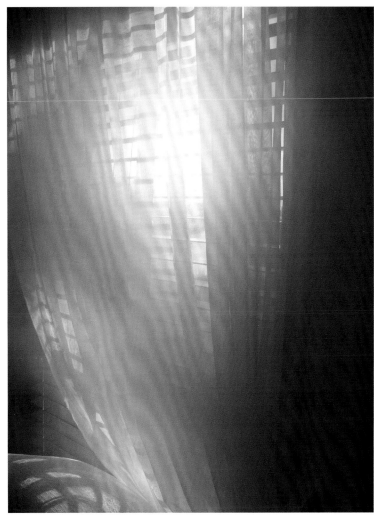

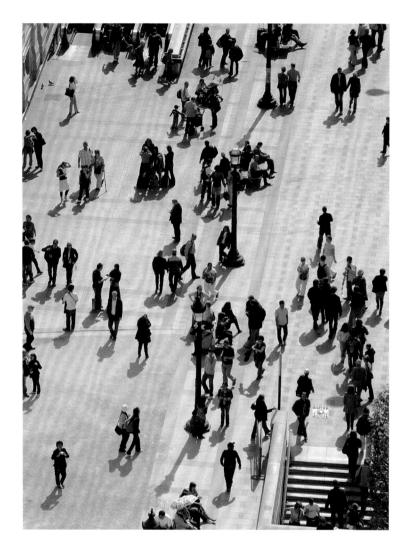 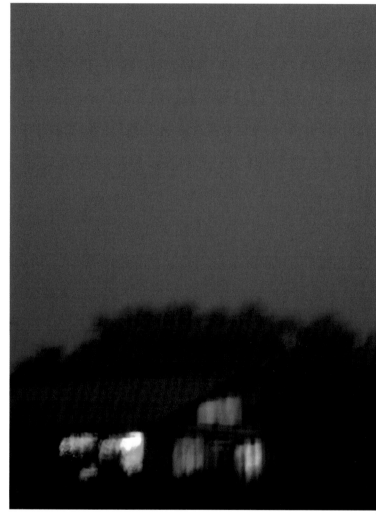

[35] Lost, 2012

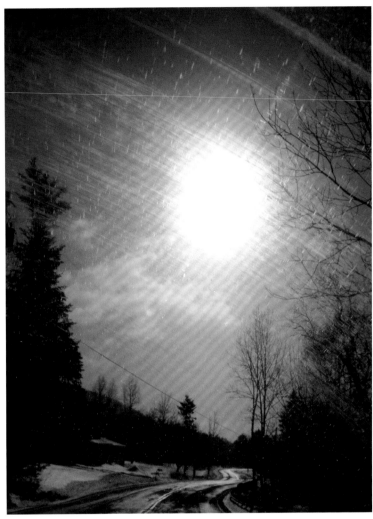

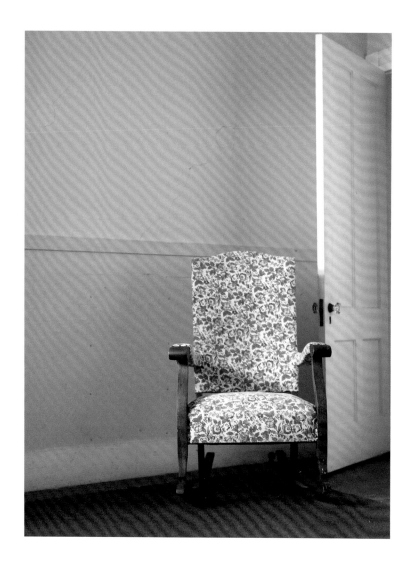

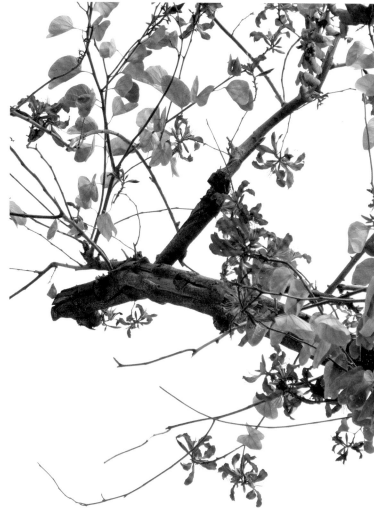

[36] Missing Stair, 2012

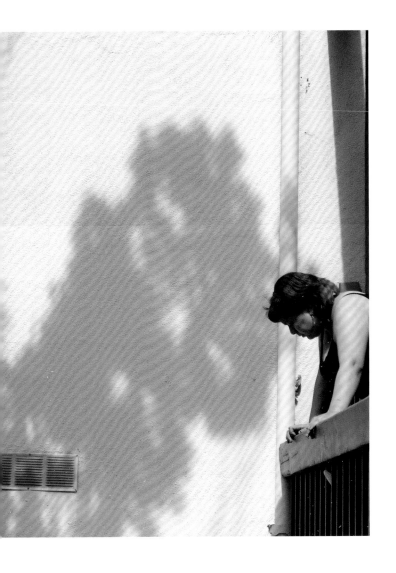
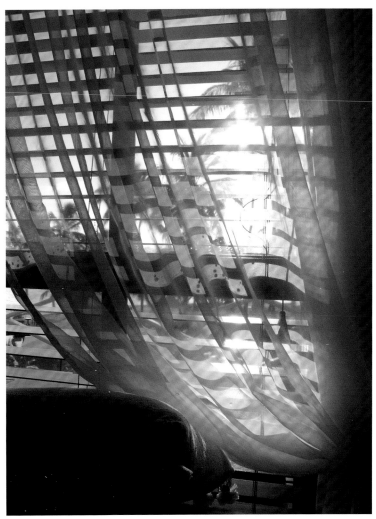

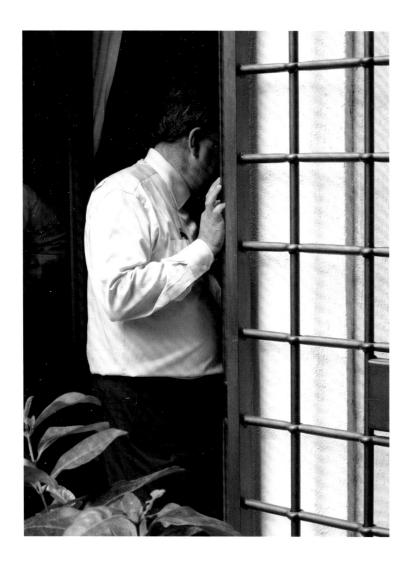

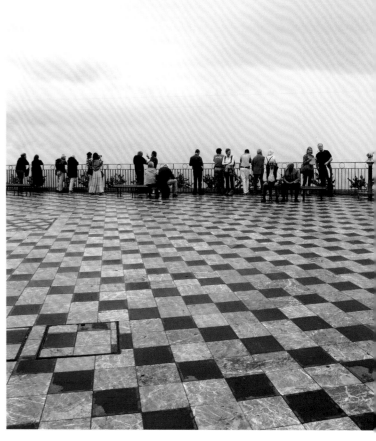

[37] On the Edge, 2012

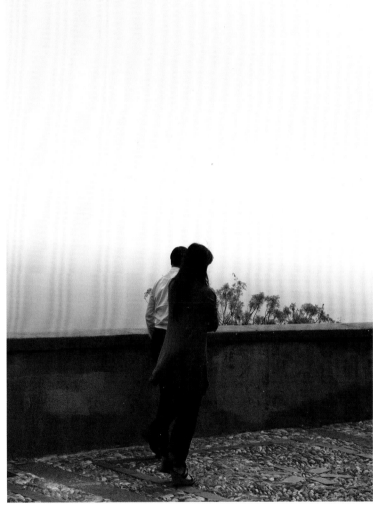

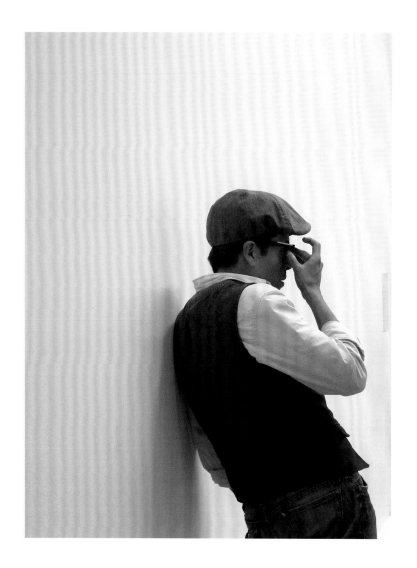

[38] Hannah, 2012

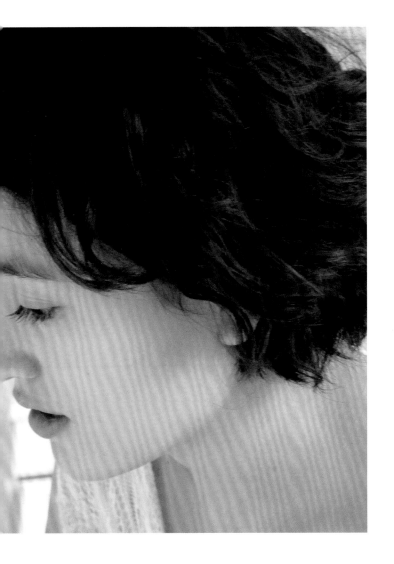
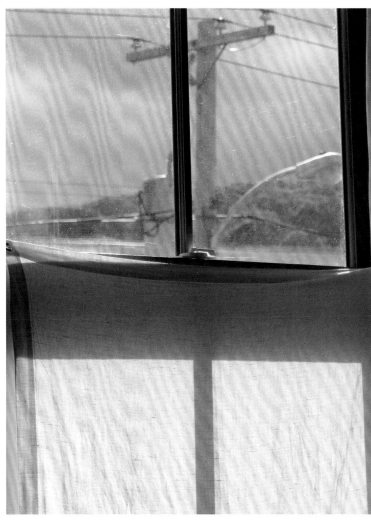

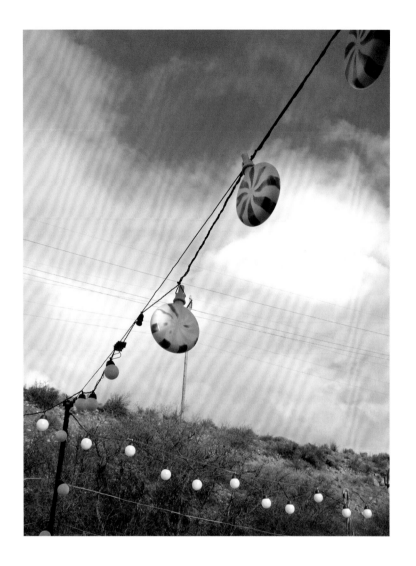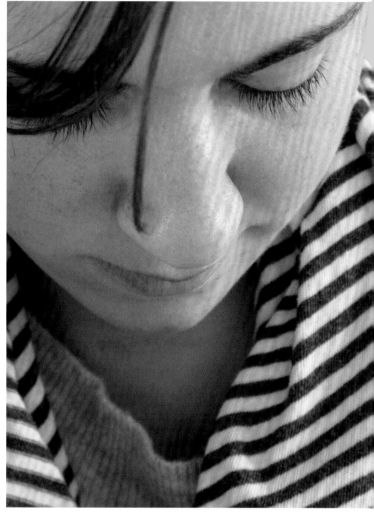

[39] Gone, 2011

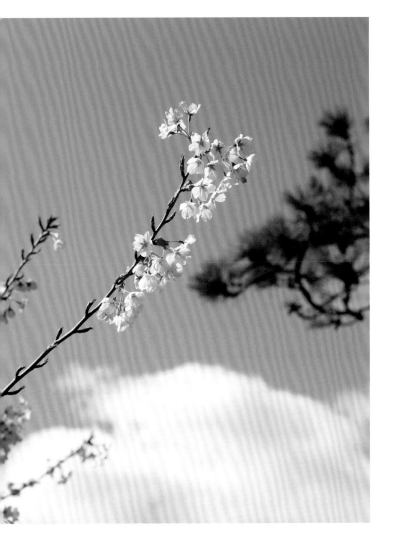
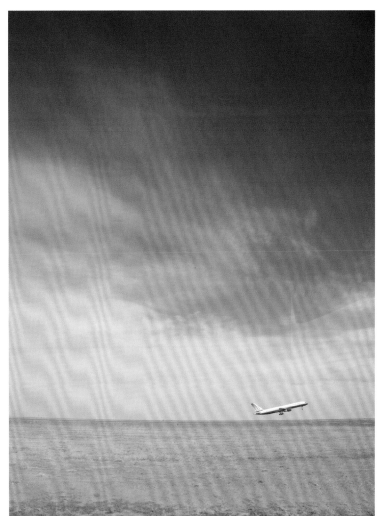

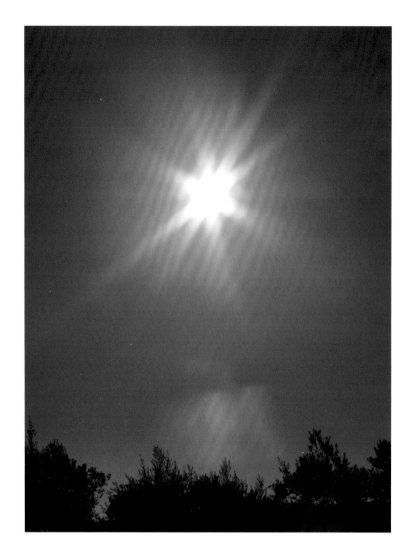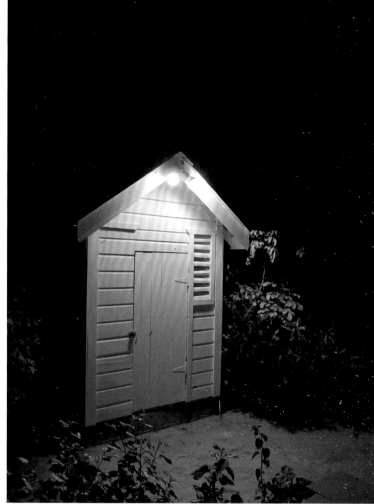

[40] Night Station, 2012

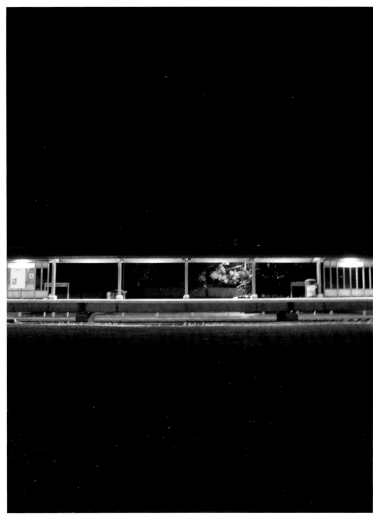

Memory, Mood, and Life's Disjunctions

VICKI GOLDBERG

"Our memories are card indexes consulted, and then put
back in disorder by authorities whom we do not control."

CYRIL CONNOLLY — *The Unquiet Grave*

Memory is evasive, deceitful, and accommodating, rather like photography. Photography was referred
to in its infancy as the mirror with a memory, and so it is, and it has obligingly expanded (or invented)
memories we could not have otherwise. We recall how Lincoln looked, and Mao, and great grand-
mother Edith; we can bring to mind certain places in Paris before Haussmann leveled them for what
seemed like a good cause; and we know what Hitler's rockets did to London for a bad one. But pho-
tographs never tell the whole story because they are incapable of doing so. The frame is too cramped
and the field too wide, the people too self-consciously posed, the subjects too dependent on the
viewer's position in place, time, personal history, and store of knowledge – just who was Haussmann
and who gave him leave to reimagine a city?

Memory is equally imperfect. Details seep away for lack of space in the storage compartment
or an inadequate retrieval program, while others stick around unbidden. Important matters get re-
pressed. Wishes, self-delusion, and the pleasure of a good story construct a new whole out of avail-
able fragments. And sometimes the mind, that tricky system, clings to a couple of moments, images,
words – vague glimpses of a story seen through a fog of forgetting, like the words of a song that
cannot get past the tip of the tongue.

Sandi Haber Fifield's photographs float on the colors of memory, mood, feeling, and suggestion.
They combine the indistinctness of memory with the imperfections of photography to produce elusive,
incomplete reconstructions of times, events, and sentiments at the far reaches of perception. She
shifts abruptly from one subject to the next without ever signaling that she means to change lanes:
first there's a dreamer asleep, then reflected trees drenched in turquoise, next a carousel idly perched
on a beach, and finally a peacock's opulent display (*Dreaming in Blue*); elsewhere a cliff wearing a
shroud of fog is followed by a flower in luscious bloom, then an elegant portrait by Ingres, and last a

crowd of silhouetted people in an enormous cave (*Mademoiselle*). What do progressions/collections like this *mean*?

They mean something akin to a poem that refuses to be reduced to a simple phrase. Archibald MacLeish wrote in *Ars Poetica,* "A poem should not mean/But be"... And when it comes to interpretations, once photographers send their images into the world, strangers control them. Strangers – we the audience – have personal memories and feelings that tailor responses to our individual histories. Haber Fifield's work, uncommonly open-ended and interactive, virtually invites multiple interpretations, giving viewers ample room to step into a force field of feelings from the vantage point of their own.

Her sequences, leaping through illogical hoops, revel in ambiguity, yet they cohere in mood and tone, much the way a piece of music does when the same key persists while melodies change. The clues to coherence are subtle: compositional elements recur, color plays nuanced games, and each sequence projects a consistent range of feeling. *Serene Hour* proposes a tentative essay on calmness and meditation, the images as steeped in placid gray as if the photographs had been soaked in fog overnight, the spaces as eloquently empty as a cleared mind, the watching figures as still as stones. When *White Sun* – a branch, a bird, and endless sky, the whole as pale and spare as some Oriental ink painting – suddenly changes tone with an oddly posed woman floating in a gray bedroom, it seems like an errant thought has barged in on a reverie, but then the reverie reasserts itself with a white sun at the last.

Repeated shapes and directional lines create an undertone of visual rhymes and rhythms. *Bent* pits the repetitive, rightward-falling diagonals of a flowering branch in the first picture, a yellow-leafed tree in the second, and a dying leaf in the fourth, against the two leftward-falling diagonals of a water spray and a leaning man in the third picture; the eye finds a unity among the four frames before the mind concocts one. In *Noto*, both color and composition reverberate: rounded yellow and green shapes – leaves, lights, fruit – anchor an indoor/outdoor, real/impossible, specific/abstract progression of greens, yellow, bronzy gold, and orange, plus blazing light.

Ideas and objects also reappear in different series – curtains and windows, the opposition of indoors and out, blossoms, flaring lights, statues – and sexuality or sensuality, primarily female. Several classicizing statues of bare-breasted women seen only from the waist up and one viewed from

the back baring her behind give us art, history, and sex in compact packages. In *Cornucopia* (with its draped female herm), the *Mona Lisa*, that female icon, is followed by a pair of shapely female legs in a mini skirt, and the last picture in the series finds a reproduction of Caravaggio's *Boy with a Basket of Fruit* on the ground, a painting generally thought to be a homosexual invitation.

As most of the Western world reads from left to right, all of these four-photograph sequences imply narratives, albeit narratives as elusive as vague memories and as imprecise as an unrecognized feeling. *Sunday Morning*, for example – curtains, a flower on the bed table, and ads for art shows in the Sunday *New York Times* – suggests an hour of lazy gray peace; *Mare Ionio* might be an afternoon's sunlit meander, richer in detail than many a Twitter post. Most of Haber Fifield's "stories" throw closure overboard, for their structure dwells in some unmapped emotional territory rather than the structured regions of intellect, and emotions are, well, endless. Her series do not exactly end but merely finish; it is left to you and me to put a period on the last sentence – or not.

She does not set out to write stories or sentences or even logical progressions. As much an editor as a photographer, Haber Fifield sifts through hundreds of photographs in her archive, picking out some that spark memories or light up a response when they join forces. Images speak to one another and, like words, take on new and different meanings when paired or fashioned into sequences. Every photographer edits her work to find the best images, for no one creates a masterpiece every time out, but sequencing is more like casting an ensemble. Every member should speak well, but more importantly, they should respond to cues and speak to one another. Haber Fifield edits to chance upon combinations that call up an intuition, a voice, a poetry in resonant tones. Her images are decidedly talkative: they speak to us and engage in dialogues among themselves. We cannot always understand them precisely, but the mood finds other means of communication.

As fragmentary and disrupted as they are, her multi-part photographs mirror familiar but largely unacknowledged conditions of our lives. The images move in fits and starts as memory does, as time tends to, as dreams do, as feelings present themselves. At one time or another, everyone has noted what might have seemed like a minor detail yet ignited our feelings or memories (think of Proust's madeleine), or some insignificant event insists on climbing out of memory and creating mind-pictures that are often inventions of the moment. Times and reactions, like dreams, can only be

partially reconstructed, yet an impulse nags us to define an unbroken and rational path through our random and ungovernable experience. Sometimes we simply, unconsciously, make one up.

All the while, even as her individual sequences hold together like messages couched in hints, innuendos, and intuitions, Haber Fifield plays with the imperfect and sometimes deceptive vision of the camera and the fragmentary (and sometimes deceptive) nature of human vision and perception. Blurred landscapes and muzzy views through windows and curtains suggest that neither machines nor people see clearly all the time. (Haber Fifield's own vision is poor without glasses, not an altogether unusual condition for photographers, who may have more than the usual desire to see the world.) Our own vision is frequently blocked in her photographs: people and heads are seen from behind, or from too far away to identify, or reduced to shadows. Photography readily obscures whatever is behind the main event, and even when it apparently registers an entire scene, it sees less than the human angle of vision. Haber Fifield's images go farther: a hand comes in at a side of the frame without an arm or person to support it, part of a leg shows up in a mirror, half a face with one eye looking off takes up most of a space. Human vision actually encounters many an amputated scene like these in passing but either fails to register them or seeks the missing parts or unconsciously fills them in, the mind preferring a rational whole.

So what we are looking at in these photographs is often looking itself. A man looks into a house from the edge of a door. People line up to look at the sea or stare off at the landscape. Window after window offers a view outside or blocks one. Blurry images one after the other speak to the blur of fast motion, the blur of peripheral vision and nearsightedness, the blur imposed by imperfect windows, by curtains, blinds, and screens, and the blur that dreams become as they drift away upon waking. Seeing may be believing, but what we see in life or photographs may not be quite what's there.

The camera has its own mode of looking, one that long ago changed the way people see and expect to see; a good photographer injects an individual vision into the mix. Haber Fifield's vision embraces ambiguity, suggestive detail, and the void, that vast absence that is the sky, the endless expanse of the sea, where only a quaver of leaves may define the edge of stillness.

And she courts the quizzical tricks photography so readily plays. It doesn't always look clearly at the world. It loses focus, producing tenuous realities. Lights flare when the camera stares at them

directly, much the way a bright light acts on eyes accustomed to the dark. The camera has a mind of its own, too. When Haber Fifield photographs a small building around sunset while there is still light on earth, the façade glows with light but utter darkness swallows the other walls (*Night Station*). The sun seen through a telescope (*Broken Eclipse*) develops a line across its surface as well as a black sky where the eye saw a blue one. Photographing the moon at night turns that stable disk into a vigorous and many-armed star (*Night Station* again). The photographer ends up as surprised by certain pictures as we are.

She also encourages her instrument to fool the eye at times. Directed to excerpt small slices of whole objects, the camera conjures up an unrecognizable world, no Photoshop needed (and Haber Fifield doesn't use that new stand-by, except occasionally to polish her color). Pointed down at a red tabletop, her camera came back with an abstraction (*Luck*); pointed down toward a swimming pool, it photographed a turquoise shimmer harboring ghostly trees upside down (*Dreaming in Blue*). She photographed a tiny fraction of a leaf-patterned dress as it brushed past a live leaf; the real and the representation can barely be distinguished (*Belize Dress*). But then, that is increasingly happening to us, and has been for some time.

If looking in its many guises recurs frequently in this work, disjunction, an acute reflection of contemporary life, is a constant. Disjunction and rapid, haphazard change have been gathering force in the world outside our minds at an increasing rate over the last two centuries. Time and motion began to accelerate with the invention of the steam engine. Railroad travel altered the way people saw the landscape, turning it into a progression of images unrolling across a window, often seemingly unrelated, unclear, indistinct – no longer the old, safe, stable world.

By the beginning of the twentieth century, as cars sped up this phenomenon, advertising expanded it into the realm of still images. You could find liver pills, corsets, and hardware pictured on the same page. In the 1920s, avant-garde artists like Hannah Hoch, who played with collage, and filmmakers like Dziga Vertov already acknowledged this common and steadily increasing experience in life and the media with a surge of unexpected jump cuts. When photo magazines like *Life* and *Look* took over in the 1930s, illustrations of baby food and plane travel muscled in on pages next to photographic essays about wars or medical devices.

In the 1960s, when images were so omnipresent they were creating traffic jams in the mind, art like Eduardo Paolozzi's *The History of Nothing* and Stan VanDerBeek's *Movie Drome* experimented again with the chaotic progression of unrelated images. Television enshrined such disparities in the lives of millions: commercials for fast cars or aids to digestion interrupted – and still interrupt – scenes of love and murder. More recently, postmodern literature and occasional films continue the experiment in their own fashion.

The digital world has raised disjunction to a dazzling extreme. The click of the camera is now like the click of the computer, image to image, info to output, merging into a stream of bits the machine can embrace but the overloaded brain finds slippery. The picture archive in your iPhone skips as fast as a swiping finger from portraits to places, from sunsets to pets. Surfing Flickr and similar web sites produces a confetti toss of images that scatters through the mind on its way to drifting out. Haber Fifield takes up this omnipresent and chaotic element of modern life and turns it into poetic channels.

A thread of something larger than the disjointed nature of contemporary imagery, larger even than memory and perception, runs through many of her sequences. The seasons come and go before our eyes: trees in full bloom are followed by blossoms falling or leaves dying. *Broken Eclipse,* this book's first image, begins with a broken, possibly ancient, statue; goes on to a view through a window onto a landscape too indistinct to be understood; then to an eclipse that is in fact not the sun but the heavens themselves eclipsed, having turned entirely black; and the fourth photograph is of footsteps in the sand, traces that will not last, emblems of the unremitting advance of time and its alliance with oblivion. Time – and multiple images in sequence are in themselves attempts to extend the limits of photographic time in single shots – is everyone's time, the times of a rotating planet, the fullness of spring and the decay of autumn, a well-worn metaphor for a life and death beyond flowers. The trajectory of life, quietly acknowledged more than once, lends a subtle air of poignancy to Haber Fifield's parade of intuitions, taking us far beyond the threshold of our memories into the very marrow of our lives.

Biographical Notes

SANDI HABER FIFIELD

was born in Youngstown, Ohio. She has an MFA in photography from the Rochester Institute of Technology and is the recipient of a New York State Creative Artists Program Grant. Her work has been exhibited in notable galleries and museums throughout the United States including the Art Institute of Chicago, the DeCordova Museum, the Museum of Modern Art, the National Museum of American Art, and the St. Louis Art Museum. Haber Fifield's photographs are held in numerous private and public collections – the High Museum of Art, the Library of Congress, the Los Angeles County Museum, and the Museum of Modern Art among others. *After the Threshold* is Haber Fifield's third monograph. In 2009 her book of grids and multiple image installations, *Walking through the World*, was published (Charta), and in 2011 *Between Planting and Picking* was released (Charta). Additionally, Haber Fifield's work has appeared in *Fabrications* by Anne Hoy, *Picturing California* by Therese Heyman, *Defining Eye: Women Photographers of the 20th Century*, and *The Photography of Invention* by Merry Foresta. She resides with her family in Connecticut.

VICKI GOLDBERG

is the author of *The Power of Photography: How Photographs Changed Our Lives* (Abbeville, 1991). This, with her *Margaret Bourke-White: A Biography* (Harper and Row, 1986) were each named a best book of the year by the American Library Association. Most recently, Goldberg is the author of *The White House: The President's Home in Photographs and History* (Little Brown, 2011). Additionally, she is coauthor of *American Photography: A Century in Images* (Chronicle Books, 1999) and editor of *Photography in Print: Writings from 1816 to the Present* (University of New Mexico Press, 1988). She is the recipient of numerous awards for her work, including the International Center of Photography's prestigious Infinity Award in 1997. Goldberg lectures widely and has written on photography and the arts for *The New York Times, American Photo, Vanity Fair,* and other publications.

In Gratitude

To John, twenty-eight years after the threshold,
And to Ben and Jocie for making each year better than the last.

To Rick Wester for his collaborative spirit, wise guidance, and above all, his friendship. To Arlette Kayafas and Kathy McCarver Root for their faith and determination. To Vicki Goldberg whose clarity of thought and beautiful language brought each of these images into sharper focus. As always, to my technical guru, the amazing and generous John Hafey. And, to Klaus Kehrer and his team whose vision brought *After the Threshold* to the page.

© 2013 Kehrer Verlag Heidelberg Berlin,
Sandi Haber Fifield and authors

EDITING AND SEQUENCING Sandi Haber Fifield and Rick Wester
TEXT Vicki Goldberg
PROOFREADING Tom Grace
IMAGE PROCESSING Kehrer Design Heidelberg (P. Horn)
DESIGN AND PRODUCTION Kehrer Design Heidelberg (K. Stumpf, T. Streicher)
COVER IMAGE Luck, 2012
FRONTISPIECE Broken Eclipse, 2010
ACKNOWLEDGEMENT IMAGE The Odyssey, 2012

BIBLIOGRAPHIC INFORMATION PUBLISHED BY THE DEUTSCHE NATIONALBIBLIOTHEK
The Deutsche Nationalbibliothek lists this publication in the Deutsche Nationalbibliografie;
detailed bibliographic data is available on the Internet at http://dnb.d-nb.de.

Printed in Germany

ISBN 978-3-86828-364-8

Kehrer Heidelberg Berlin
www.kehrerverlag.com